DRAWING
Faces

Learn How to Draw
Facial Expressions, Detailed Features,
and Lifelike Portraits

Lise Herzog

First published in 2019 as *Visages & expressions: 50 modèles pour débuter* in Paris, France, by Editions Mango.

Published in the US by:
ULYSSES PRESS
PO Box 3440
Berkeley, CA 94703
www.ulyssespress.com

ISBN: 978-1-64604-320-0

Printed in the United States
10 9 8 7 6 5 4 3 2 1

Acquisitions editor: Keith Riegert
Managing editor: Claire Chun
Project manager: Kierra Sondereker
Editor: Joyce Wu
Proofreader: Renee Rutledge
Front cover design: Flor Figueroa
Interior design and layout: what!design @ whatweb.com
Production assistant: Yesenia Garcia-Lopez

CONTENTS

BEFORE YOU BEGIN

Drawing a face can seem difficult. How do you convey a certain realism? How do you capture the expression of features, faithfully depict your subject, or find a way to accurately draw the nose and eyes?

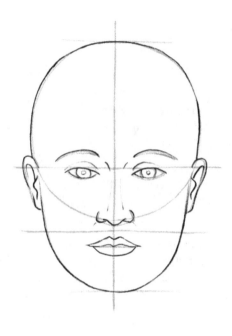

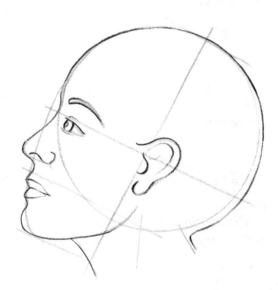

First of all, you can use a few fairly simple rules of proportion. But you don't have to apply them to the letter to give your drawing style and expression. Rules of proportion help you put each facial element more or less in its place so that the face does not "break down." Once you internalize a few of these guidelines, you can free yourself to experiment a little.

Because each face is different, how you draw a person's face will depend on whether they are real or from your imagination, whether they are a man or woman, or where they are from. All of this information will help you modify the proportions of the face and, of course, change the shape of the different features that make it up.

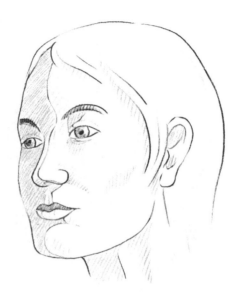

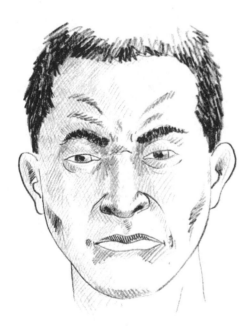

People often want to draw someone they know. And after the drawing is done, it's not uncommon to find that the result doesn't seem to look like the model at all. However, if you look at the drawing without comparing it to the model (a real subject or photo), you may realize that you can still recognize the person in the drawing.

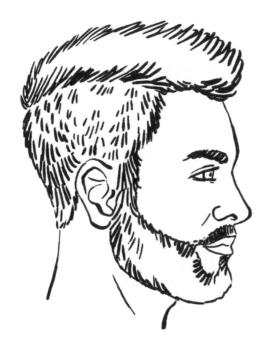

Furthermore, if you show your drawing to someone else, there's a good chance that person will recognize the subject also. How is this possible? Even if your drawing doesn't reproduce every detail of a face, it may still capture the model's characteristic features.

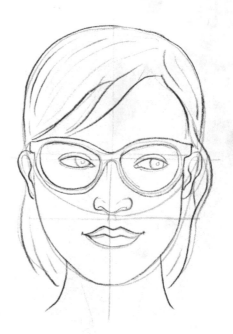

When you draw someone's face, first try to pinpoint what that person's identifying features are, such as the shape of the chin, the droop of the eyes, or the length of the forehead. Then focus on these defining elements and build the rest of the face around them. Don't hesitate to caricature them a bit. Accessories, like a pair of glasses or a beard, are invaluable aids.

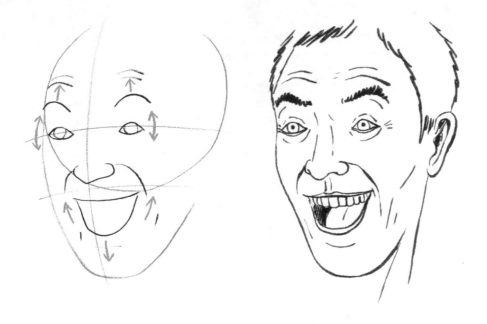

To accurately represent expressions or emotions, try observing yourself in a mirror. Smile and watch where your face creases—which part goes up or down, etc. Imagine invisible arrows that show the direction of your facial movements.

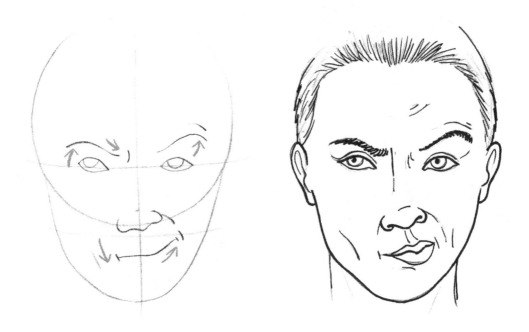

There are a thousand ways to represent the nose, mouth, or eyes and to make your drawing realistic. Depending on your perspective, you can simplify or exaggerate certain details.

The more you observe and draw, the more you will refine your perception skills. It may be that one day you think your drawing is perfectly proportioned, but the next day your impression of that same drawing has changed. Consider why and make a new drawing without getting discouraged. Each drawing, easy or difficult, is an essential step along the road of progress.

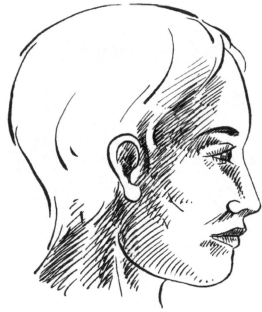

There are many tools available to help you refine your drawing and achieve your desired look. Some tools, such as regular pencils, graphite drawing pencils, and old felt-tip markers, allow you to make lighter or darker lines depending on the pressure you use. Others, like some pens and India ink, are dark from the start and leave little room for error. However, these darker materials make it easier to erase a base sketch. Ballpoint pens are interesting because they can be very soft and unobtrusive while still providing beautifully dark colors. And indelible ink can allow you to rework a drawing with a wet technique.

As complicated as a face is, it's made up of simple angles and shapes, including circles, ovals, and straight lines. You can therefore begin by sketching a "frame" of simple shapes, which can then be "dressed" by redrawing the face in more detail and with contours. For these base sketches, it's best to use graphite pencils, which are forgiving and allow you to easily shade and erase your lines.

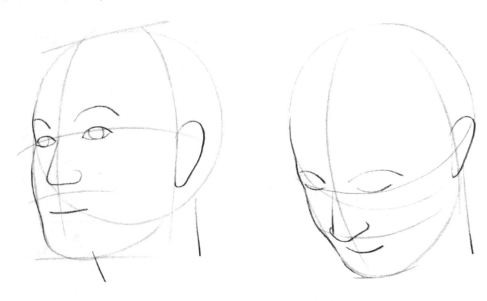

Whichever medium you prefer, take time to observe the subject, and embrace mistakes. Each error sharpens your gaze, and each attempt gives you more confidence!

To draw a face, follow a few rules of simple proportions. These rules of proportion bring consistency and realism to your drawing.

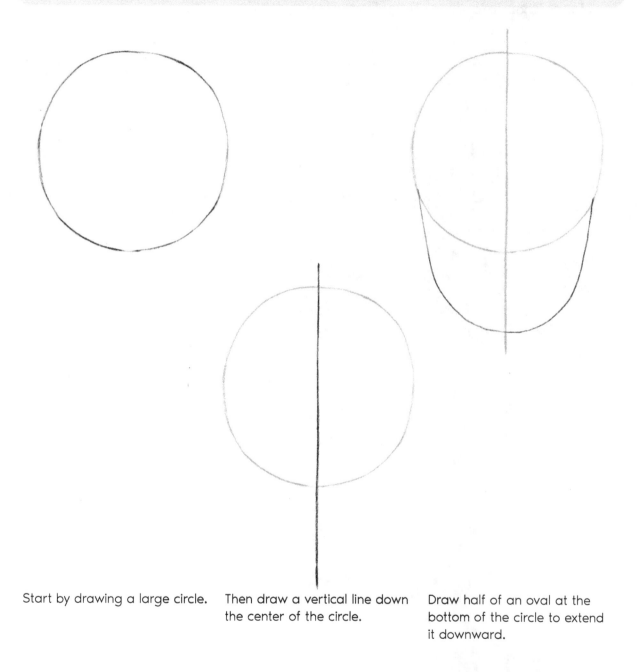

Start by drawing a large circle.

Then draw a vertical line down the center of the circle.

Draw half of an oval at the bottom of the circle to extend it downward.

Frame the top and bottom of the face with two horizontal lines, then draw a third line halfway between them. Throughout this book, I'll call this line the center line.

Add another horizontal line halfway between the center line and the bottom line, splitting the bottom half into quarters.

The eyes fall just below the center line. The eyebrows go just above it. This line is also where the tops of the ears meet the skull.

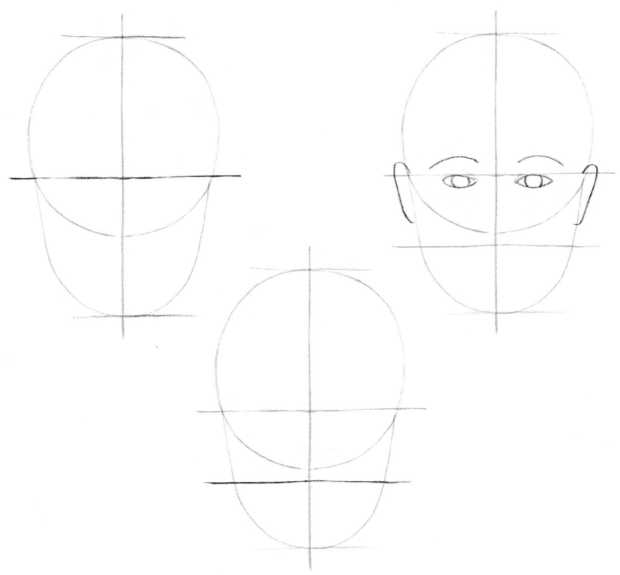

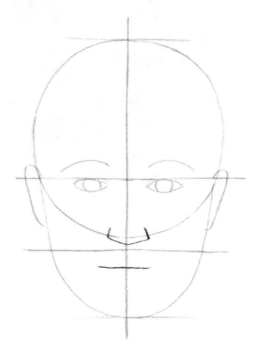

The nose and mouth go on either side of the quarter line.

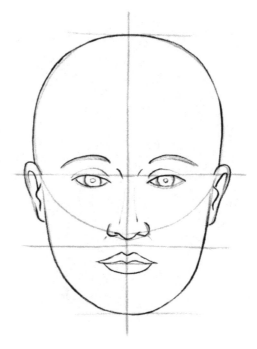

Finally, refine the face by adding details.

FINISH YOUR DRAWING WITH A PENCIL

To bring a drawing to life, you can create a sense of volume with shadows and emphasize certain details to give them more presence.

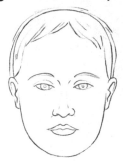

Add any last details, such as the hair, before erasing the lines of the base sketch as much as possible.

Although graphite pencils come in varying levels of softness and darkness, you can also adjust the intensity by exerting more or less pressure on the tip or by tightening or superimposing the hatching.

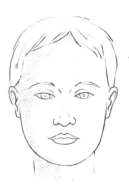 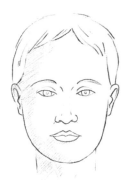

To add depth to your drawing, determine where the light is coming from and which part of the face is illuminated. The shadows go on the opposite side of the lit areas. Start with light hatching and adjust the depth of shadows as you go.

As you create new shadows, go over the first layer of hatching to darken it more. This work must be very gradual in order to preserve the light and not weigh down the drawing.

Finish by darkening the smaller details, such as the pupils or the eyebrows, to attract the viewer's eye and give the face a sense of expression.

PRACTICE PAGE

Try your hand at finishing the original sketch.

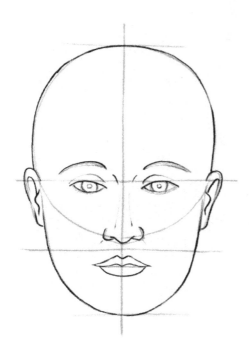

THE BASICS OF THE FACE IN PROFILE

It's easier to draw a face in profile because the perspective is less pronounced. That being said, be sure to give enough volume to the back of the head, which is easily flattened.

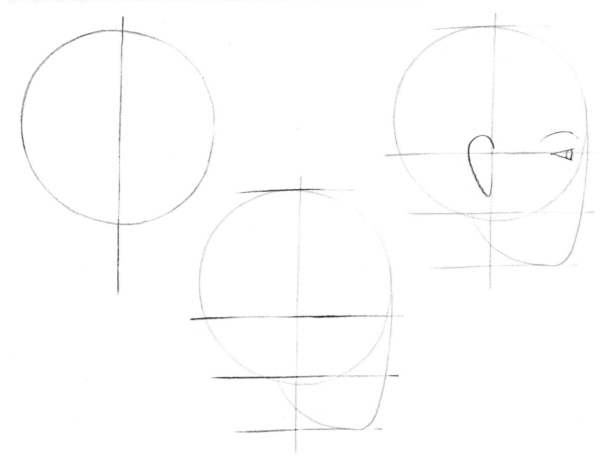

The base sketch begins the same way as the frontal view.

However, the half oval that extends from the bottom of the face should now be more pointed and rest mainly to one side of the vertical line.

Only one ear is visible from this view, and it goes on the cross in the center. Draw a triangle on the side of the face, opposite the back of the head, for the one visible eye.

The nose and mouth are silhouetted along the half oval. The bridge of the nose begins near the center of the eye.

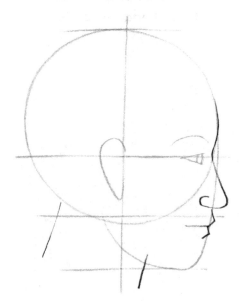

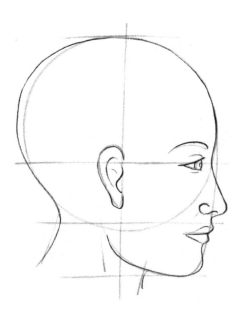

When you add details, you can choose to emphasize different features, such as the shape of the chin, nostril, mouth, etc.

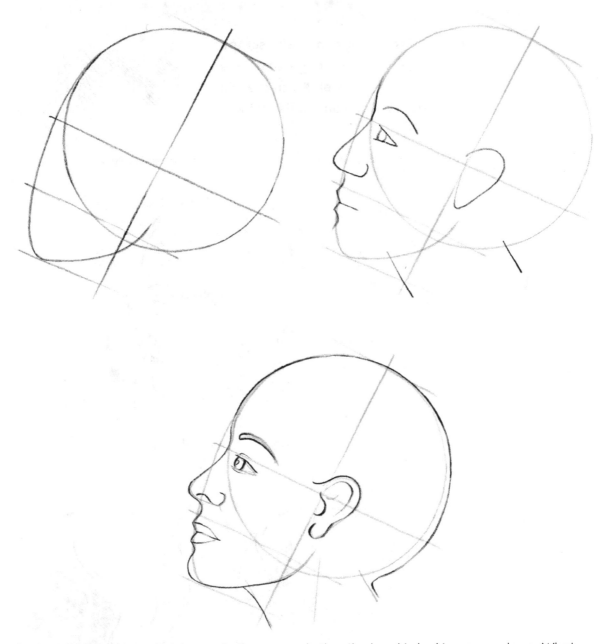

The basics of the base sketch remain the same whether the head is looking up or down. What changes is the angle of the base lines that give direction to the face. When the head tilts, the neck stretches and is no longer aligned with the rest of the body.

FINISH YOUR DRAWING WITH A FEATHER PEN

Feather pens are delicate tools that can easily scrape paper. They can be used to make a range of shade intensities, from full to thin lines. Be careful with the ink: if you press too hard on the nib, you can create inkblots that stain your drawing.

Start by redrawing the outlines and contours of the face. Then, once the ink is dry, erase the pencil lines underneath.

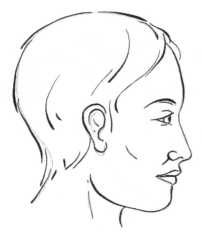
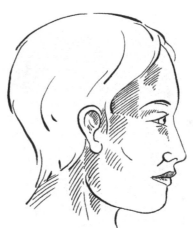

Add depth with hatching.

Continue by superimposing the hatching in the most shaded areas. Darkening these regions will highlight certain details.

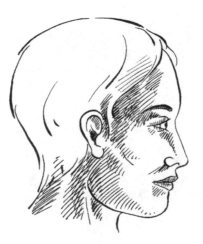
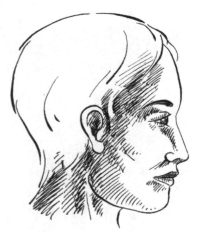

PRACTICE PAGE

Try your hand at finishing the original sketch.

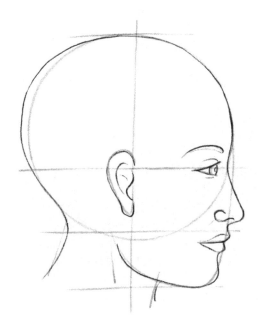

THE BASICS OF THE THREE-QUARTERS PERSPECTIVE

The three-quarters perspective is the most difficult to draw because the features of the face rest on a curved shape.

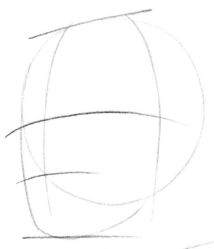

Always start with a circle to delineate the curvature of the skull. In the three-quarters view, the top and bottom base lines are straight, but the rest of them curve. The placement and curve of the vertical lines depend on the angle at which the head is turned, and the chin goes between the vertical line and the edge of the face.

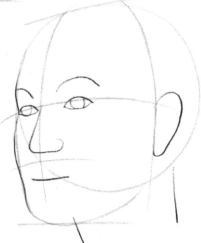

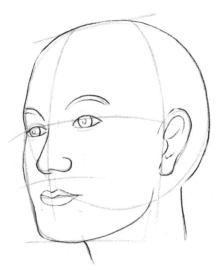

Place the facial features on the same lines as for a frontal or side view, with the far eye and eyebrow still going between the nose and the side of the face.

When a face looks down, the forehead and the
top of the head take up more space, and the
lower portion of the face shrinks.

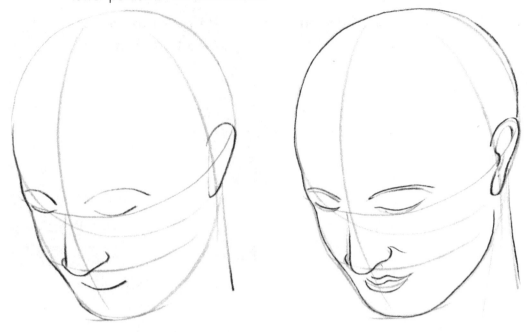

Conversely, when a face looks up, the chin and the upper neck take up
more space while the forehead shrinks. From this angle, the underside of
the nose is visible.

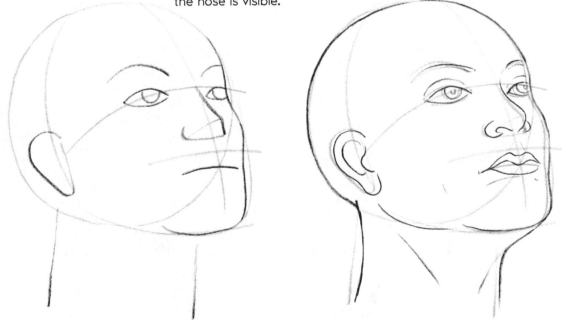

FINISH YOUR DRAWING WITH A BOLD GRAPHITE PENCIL

Instead of pressing harder on your graphite pencil to create deeper blacks, you can choose a bolder pencil to make these strokes.

After drawing the details of the face, lightly outline the areas of the face that will be shadowed.

Then fill in these areas with fine, close hatching.

You can layer new hatching on top of the initial hatches to intensify the shadowed areas. This will give your drawing a greater sense of contrast and depth.

Erase some of the outlined features, such as the back of the head, which is usually hidden beneath hair.

PRACTICE PAGE

Try your hand at finishing the original sketch.

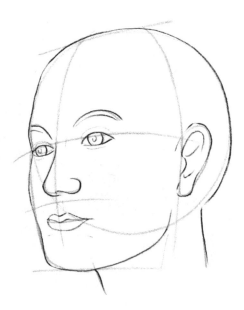

THE FACE FROM BELOW OR ABOVE

By drawing faces at sharp angles, you can evoke strong feelings and tell a story with your drawing.

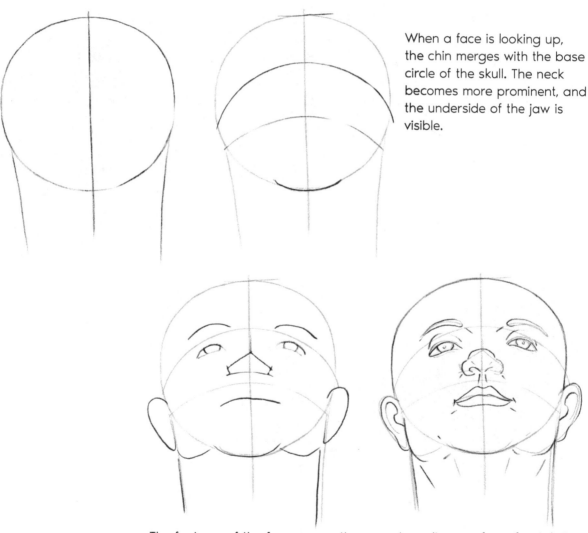

When a face is looking up, the chin merges with the base circle of the skull. The neck becomes more prominent, and the underside of the jaw is visible.

The features of the face are on the same base lines as for a frontal view, curving with the arc of the lines.

When the face is seen from above, the top of the skull is very visible. The center line shifts higher on the circle and the quarter line now curves slightly up. The eyes fall on the bottom of the circle.

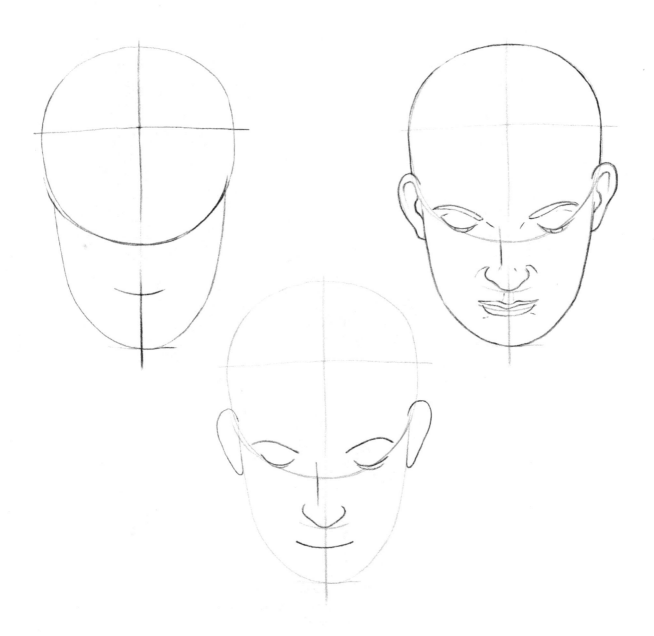

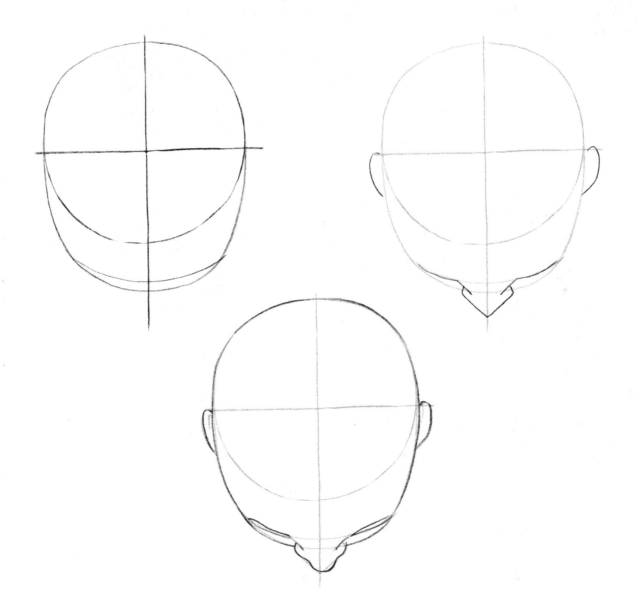

As you point a head increasingly downward, the details of the face disappear and the outline of the skull becomes more prominent.

FINISH YOUR DRAWING WITH A GRAPHITE PENCIL

Graphite is very powdery, and rubbing the lines with your finger or with a kneaded eraser can soften them.

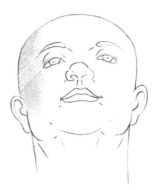

Start by lightly hatching the shadowed areas, and then gently rub the lines to blur them.

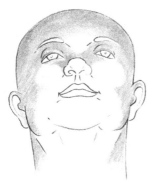
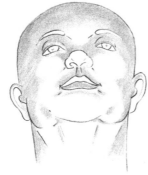

Continue in this way in all the areas that need to be shaded. You can also superimpose new lines on top of the ones you've already blurred.

Darken the details—like the eyebrows, eyes, inner corners of ears, and nostrils—that should stand out.

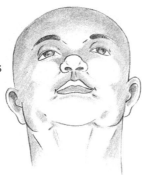

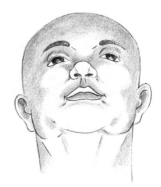

Add unblurred lines to the most deeply shaded areas for a dynamic drawing.

27

PRACTICE PAGE

Try your hand at finishing the original sketch.

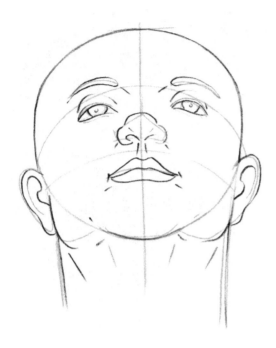

EYES

Incorporating simple shapes into your drawing of an eye will help it look more realistic. These shapes are simplified for drawings of entire faces, on which the eyes are not usually very large.

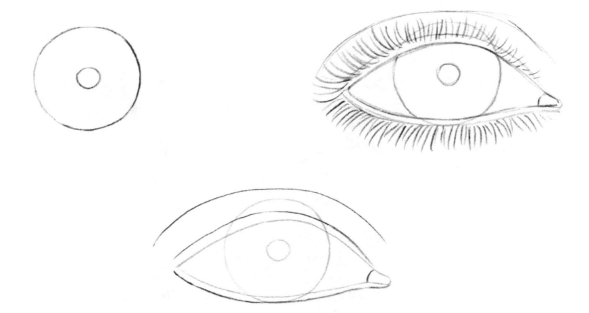

Start by drawing a circle for the iris, then a smaller circle in the center for the pupil.

Enclose most of the outer circle (the iris) within the shape of an almond with pointed ends. The eyelids can be drawn open for a neutral look, and exposing or covering more of the iris will change the expression of the eyes.

Finish by adding eyelashes.

In profile, the almond shape is halved.

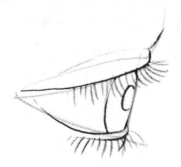

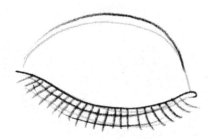

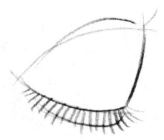

For a closed eye, exaggerate the roundness of the almond shape to add volume to the eyelid.

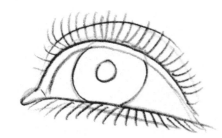

If the eye's gaze is directed upward, the base of the eye will be flatter, less curved.

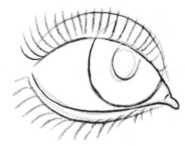

The pupil and iris can move around an open eye.

When the iris is at the top of the eye, the eyelid bulges.

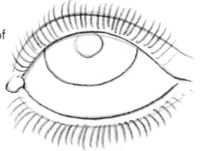

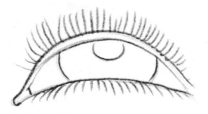

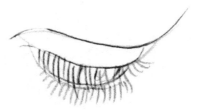

If a person's gaze is directed strongly up or down, the top and bottom of the eyelid will curve in the same direction as the gaze.

FINISH YOUR DRAWING
WITH A BALLPOINT PEN

Ballpoint pens, like pencils, allow for a variety of color
and line intensities. Shade colors can range from a light
gray to a thick black.

Start without pressing too hard, then gradually
darken the color by superimposing strokes and
exerting more pressure on the pen.

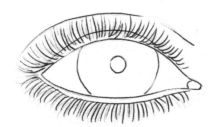
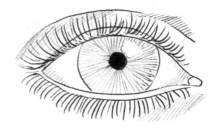

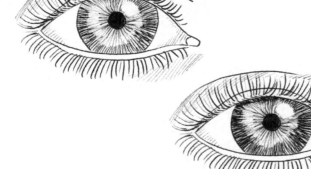
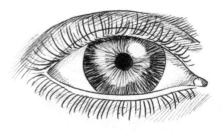

For the iris, orient the hatching around the center like rays, leaving a
touch of white to represent reflected light.

PRACTICE PAGE

Try your hand at finishing the original sketch.

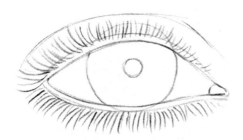

NOSES

Noses are relatively complex to draw because they're made up of bumps and hollows. It's easier to draw them in profile.

For a frontal view of the nose, sketch a long vertical line cut at the bottom by a smaller horizontal line. On the small horizontal line, add a large circle in the center and two smaller circles on either side.

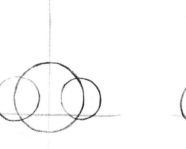

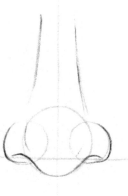

Next, draw the nostrils, which look similar to angled commas, and the sloping sides of the nose.

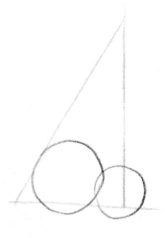

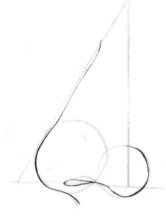

In profile, the entire nose fits into a half triangle. Only one nostril can be seen.

The comma shape of the nostril begins on the bottom curve of the smaller circle and forms a loop near the bottom of the larger circle.

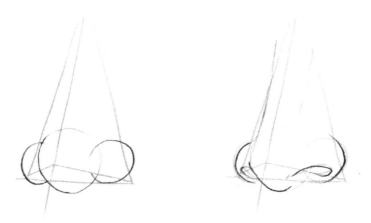

The three-quarters angle is the most complicated to draw. It helps to start with a tall pyramid. The three circles go at the bottom, overlapping the small triangle that makes up the pyramid's base. Depending on the nose's orientation, one of the nostrils will be less visible than the other, which is represented by a partial circle.

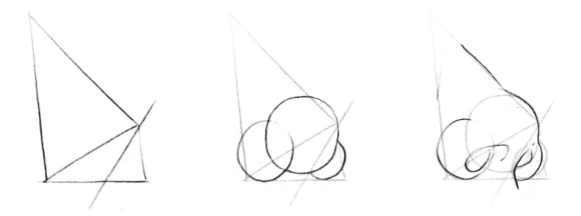

When the nose is seen from below and from a three-quarters perspective, the larger circle rises with the base of the pyramid, and the nostrils tilt.

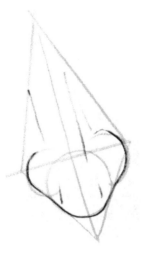

When the nose is seen from above, the nostrils disappear.

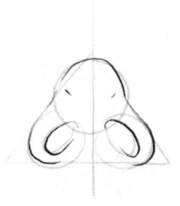

When the nose is seen from below, the bridge of the nose disappears, and the nostril holes become more rounded.

FINISH YOUR DRAWING WITH A PENCIL

Orient the pencil lines in different directions according to the slopes and curves of the nose.

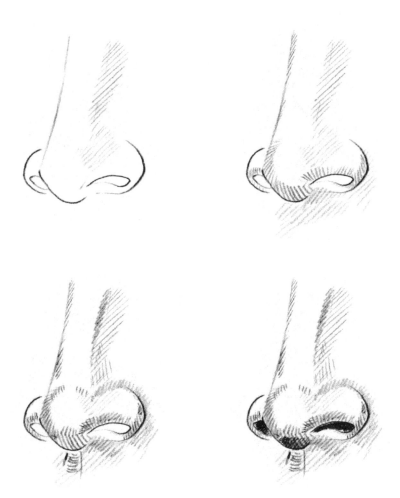

Start with light hatching. Adapt the size of the hatching to the volume of the nose. Don't hesitate to blacken the holes of the nostril to give your drawing depth.

PRACTICE PAGE

Try your hand at finishing the original sketch.

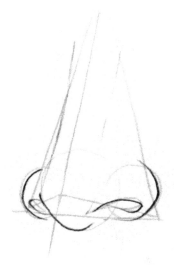

Drawing the shape of the mouth is pretty easy, but don't forget to give the lips volume.

To draw the mouth in profile, start with a sloping four-sided shape placed on top of a small circle.

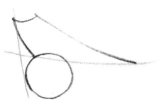
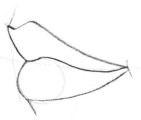

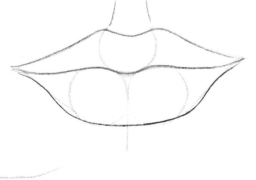

For the frontal view, draw a horizontal line with two slight bumps and a vertical line that intersects it between the bumps.

Draw three circles to indicate lip volume.

Finish by drawing a dip for the groove in the top lip, two sloping lines that connect with the horizontal one, and a rounded line for the bottom lip.

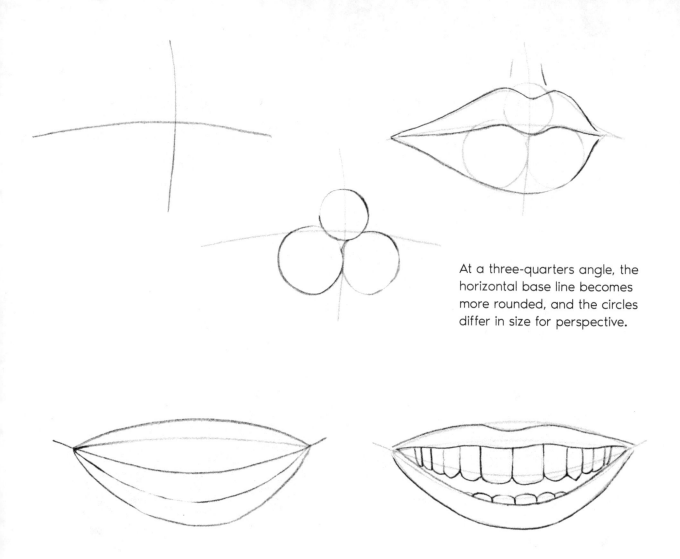

At a three-quarters angle, the horizontal base line becomes more rounded, and the circles differ in size for perspective.

When the mouth is open, the lips stretch and lose volume. The center line helps you place the teeth.

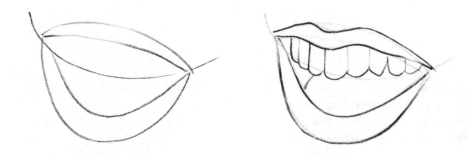

FINISH YOUR DRAWING WITH A FINE PEN

Fine pens will give you lines with uniform thickness and color.

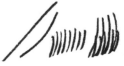

Begin by outlining the mouth.

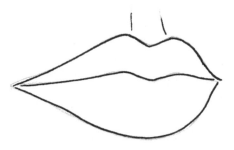

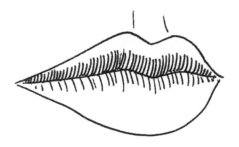

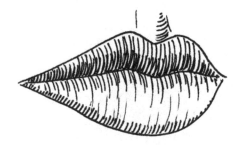

Then add hatching that follows the fullness of the lips and makes the subtle curves of the mouth clearly visible. There should be more shadows in the hollows of the lips (near the mouth opening and at the bottom of the lips) and very few lines on the more rounded parts of the lips.

PRACTICE PAGE

Try your hand at finishing the original sketch.

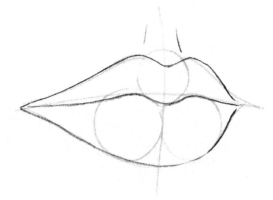

EARS

It's not necessary to draw the relatively complex shape of the ear in detail. Certain lines and shapes help to make the ears more realistic and recognizable, especially if they are less prominent in a drawing.

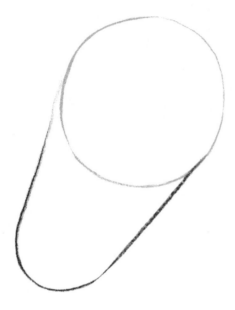

To draw an ear up close, start by sketching a circle that has an elongated half oval at its base.

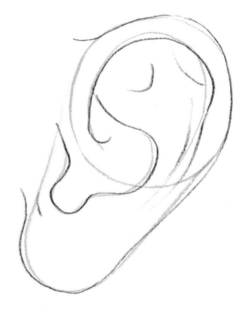

Then add different lines to illustrate the ridges, bumps, hollows, and the hole of the ear. It's best to look at an example while you do this.

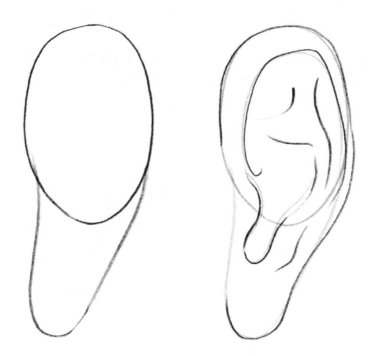

The closer you are to looking at an ear from the front, the more the shape flattens out.

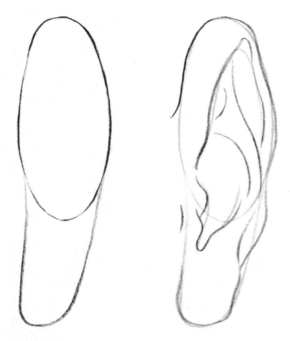

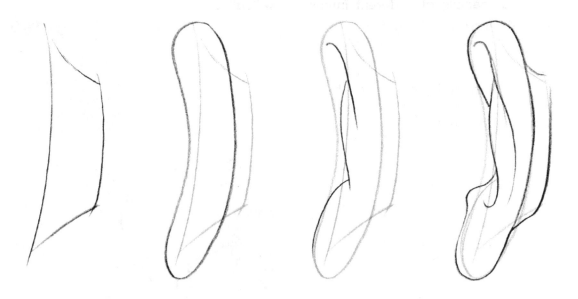

From the back, you'll see fewer shapes and details and more of the ear's rear contour and its junction with the head.

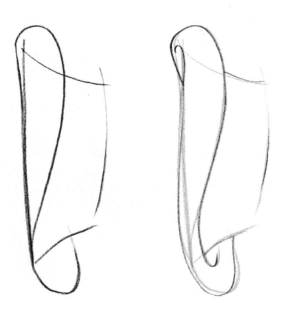

FINISH YOUR DRAWING WITH PENCILS

Using several pencils of different intensities will allow you to create a range of shadows.

Emphasize the different ridges of the ear by gradually darkening the most important hollows with a strong, bold pencil.

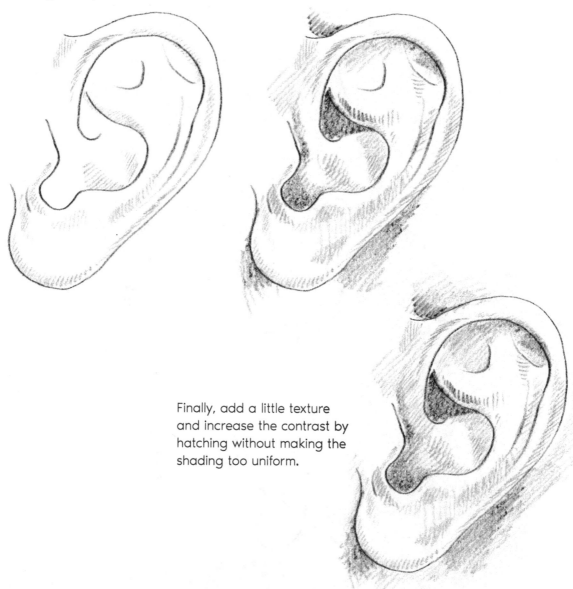

Finally, add a little texture and increase the contrast by hatching without making the shading too uniform.

PRACTICE PAGE

Try your hand at finishing the original sketch.

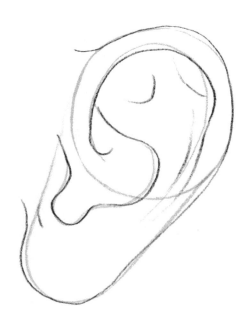

MASCULINE FACES

To draw a noticeably masculine face, use caricature and exaggerate certain features.

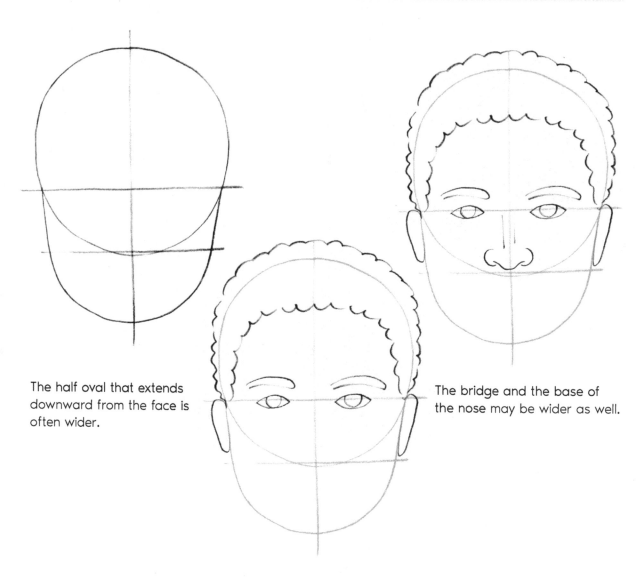

The half oval that extends downward from the face is often wider.

The bridge and the base of the nose may be wider as well.

For men, you can simply add short hair and thicker eyebrows.

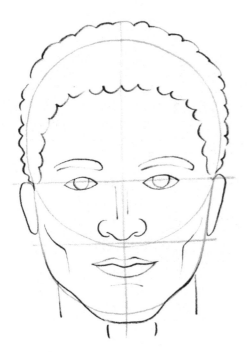

Finally, you can make the jawline broader and more angular, as well as add lines to fill in the details of the face.

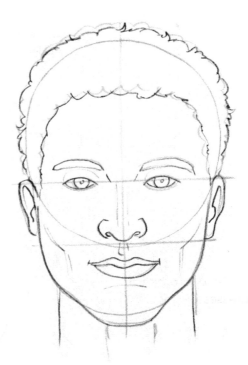

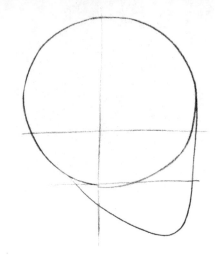

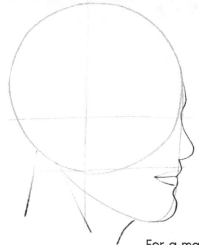

For a masculine face in profile, draw a more prominent chin and small bump where the eyebrows would be.

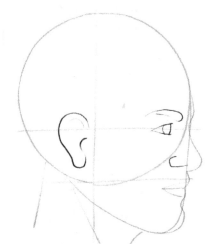

Make the nostril clearly visible and a little square.

You can also add a beard, which dresses the face.

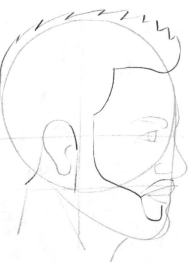

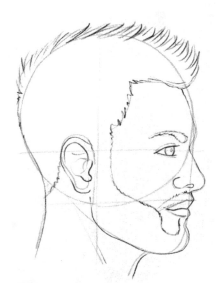

FINISH YOUR DRAWING WITH A FELT-TIP MARKER

A felt-tip marker can make both fine and very thick, dark lines.

Start by outlining the drawing. You can then erase the pencil.

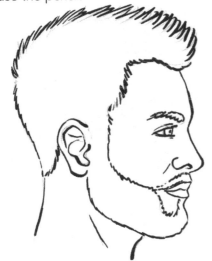

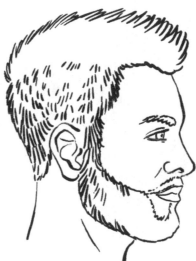

Then gradually fill in the beard and hair with small lines that give the effect of texture and volume.

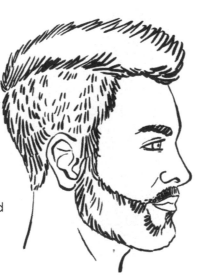

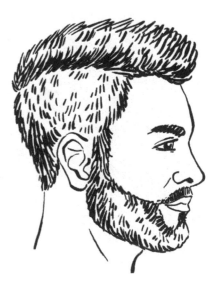

Adding a few more lines throughout your sketch can accentuate the shadows and emphasize certain details.

PRACTICE PAGES

Try your hand at finishing the original sketch.

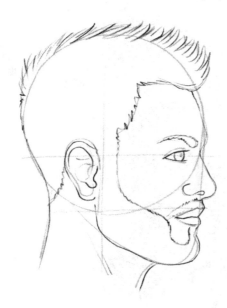

Draw your own version of a masculine face in the space below.

FEMININE FACES

As with a masculine face, certain characteristics of a feminine face can be exaggerated in your drawing.

The half oval that forms the base of the face can be narrower and more pointed.

You can also draw long hair.

The nostrils may be more delicate, the lips well-defined, and the chin pointed.

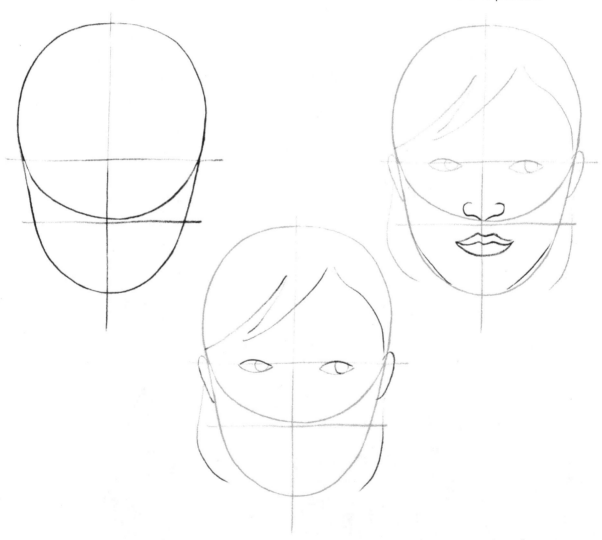

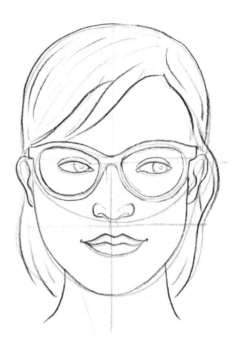

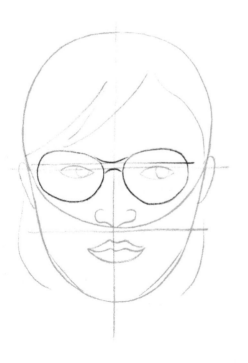

Adding an accessory, such as glasses, can help you configure and adjust proportions. This applies to any face you draw, masculine or feminine.

For a feminine face in profile, you can accentuate a pointy nose and chin. The nostrils can be delicate, and the eyebrow, thin.

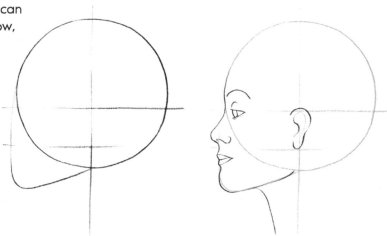

This is your chance to practice a complicated, fancy hairstyle!

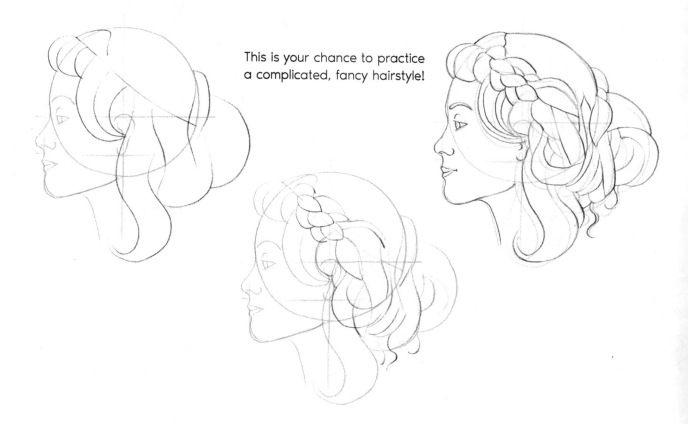

FINISH YOUR DRAWING WITH A PENCIL

Pencils allow you to vary details with finesse and precision.

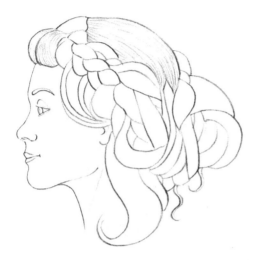

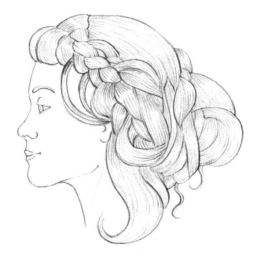

You can choose to accentuate only some of the details of the drawing. Leaving the face without texture will give an impression of youth.

When creating shadows, make sure that the pencil lines follow the curve of the hair.

Layer the lines to accentuate the shadows between different knots of hair. To give the effect of volume, leave white space to show the light's reflection.

PRACTICE PAGES

Try your hand at finishing the original sketch.

Draw your own version of a feminine face in the space below.

ELDERLY FACES

The more details you add to a face, the more aged it will appear.

For only a slightly aged face, add very few lines—just a few wrinkles. The general structure of the face doesn't change.

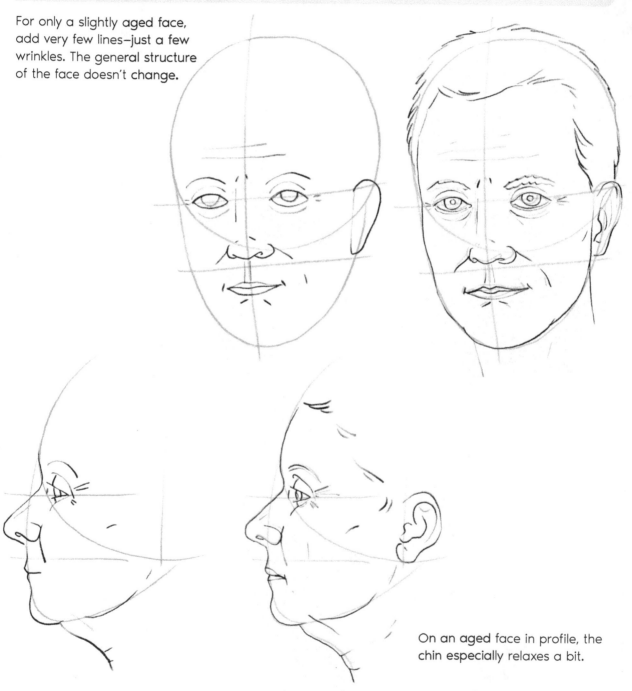

On an aged face in profile, the chin especially relaxes a bit.

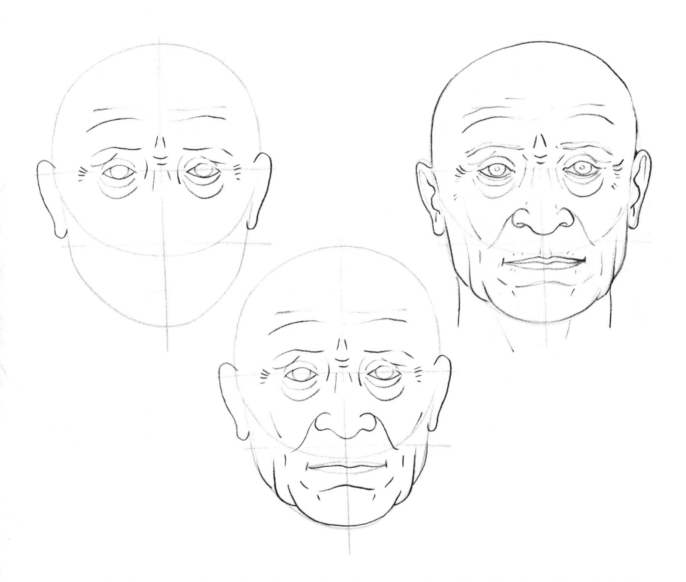

For an older face, make these alterations: enlarge the ears and nostrils, widen the chin, and shrink the eyes. The whole face will sag a little. Create folds under the eyes and on both sides of the nose.

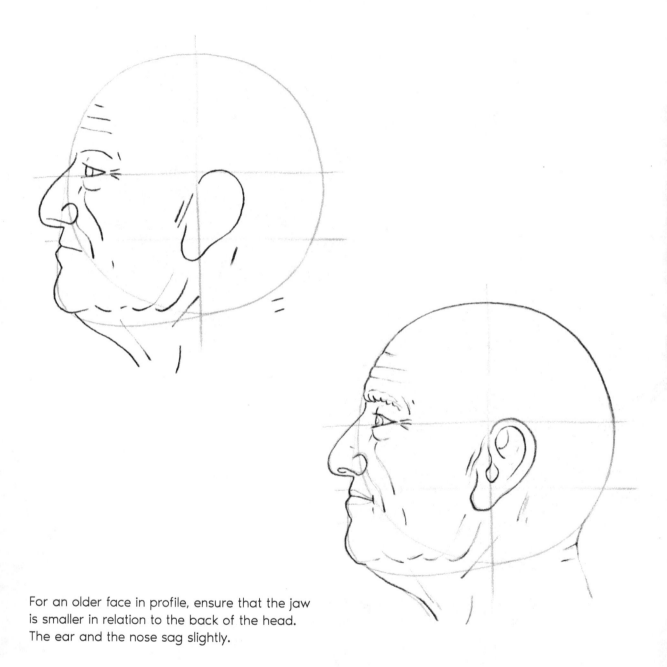

For an older face in profile, ensure that the jaw is smaller in relation to the back of the head. The ear and the nose sag slightly.

FINISH YOUR DRAWING WITH A GREASE PENCIL

Without applying too much pressure, you can create not only beautiful blacks, but also soft, powdery lines with a grease pencil. Be careful because grease pencils don't erase well.

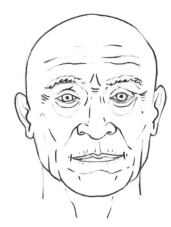

Gradually fill in the face with lines, following the natural curves. This will create an effect of wrinkled skin.

When redrawing a face, don't hesitate to add details or small, additional features.

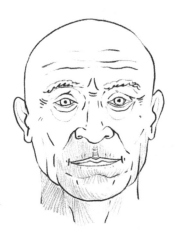

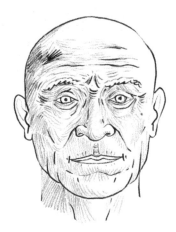

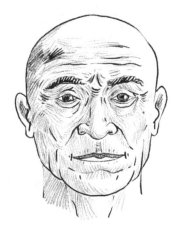

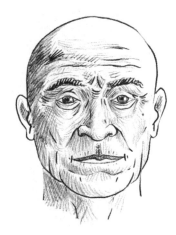

Superimpose the strokes in the shadowed areas and darken certain details like the eyes and eyebrows to make them stand out.

PRACTICE PAGES

Try your hand at finishing the original sketch.

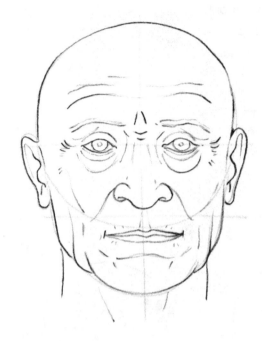

Draw your own version of an elderly face in the space below.

YOUNG FACES

For a young face, modify the proportions and draw as few lines as possible. Each additional line ages the face.

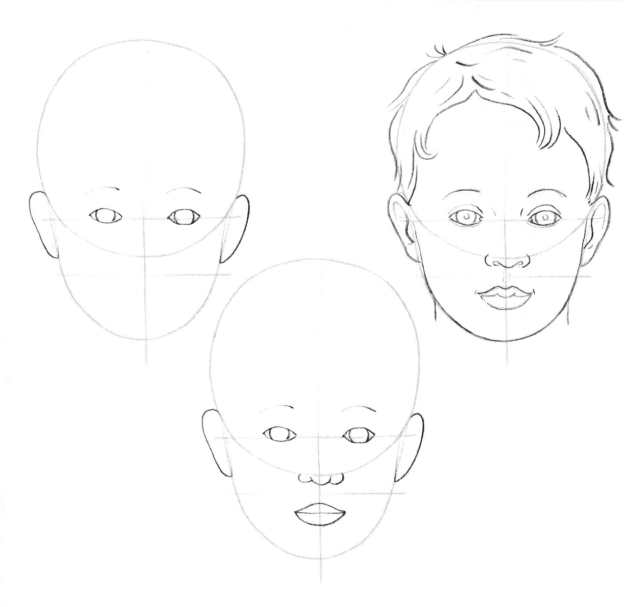

To draw a child's face, make sure that the lower part of the face is smaller in relation to the top of the head. The facial features will also be smaller and rounder.

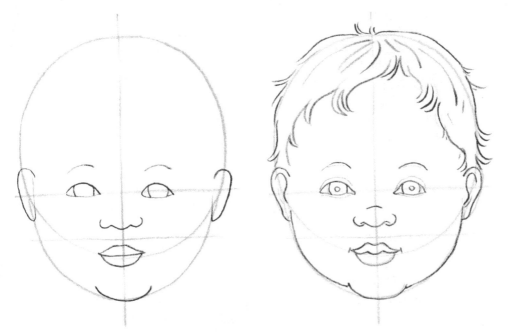

A baby's face is even rounder than that of a child or adult, and the features are closer together. The top of the head takes up a proportionally large amount of space. The younger the child, the simpler and rounder the details.

In profile, the lower part of a young child's face is much smaller compared to the roundness of the back of the head. The forehead is also very rounded. The nose and the mouth turn upward.

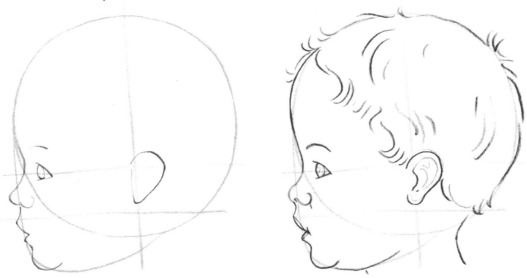

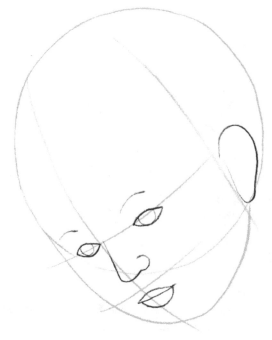

The three-quarters angle highlights the roundness of the cheeks and chin.

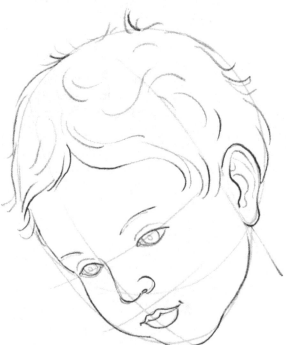

FINISH YOUR DRAWING WITH A FINE PENCIL

A fine pencil helps to bring softness and finesse to a drawing.

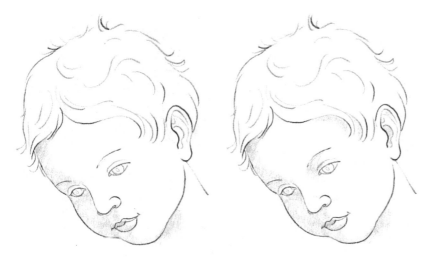

Start by uniformly shading the shadows of the face to give the skin a look of smoothness. The less texture in your lines, the more youthful and wrinkle-free the face will appear.

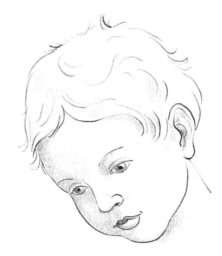

In the same uniform way, go over some of the shaded areas to accentuate the contours of the face, then finish by darkening certain details like the eyes, eyebrows, and strands of hair.

PRACTICE PAGES

Try your hand at finishing the original sketch.

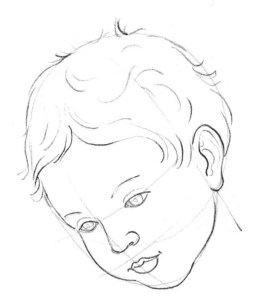

Draw your own version of a young face in the space below.

SMILES

In a smiling face, the facial features stretch upward.

The cheekbones push up, making the eyes squint and the eyebrows rise.

The corners of the mouth stretch upward. This raises the cheekbones and widens the lower part of the face.

For details, you can add small folds at the corner of the eyes and under the cheekbones.

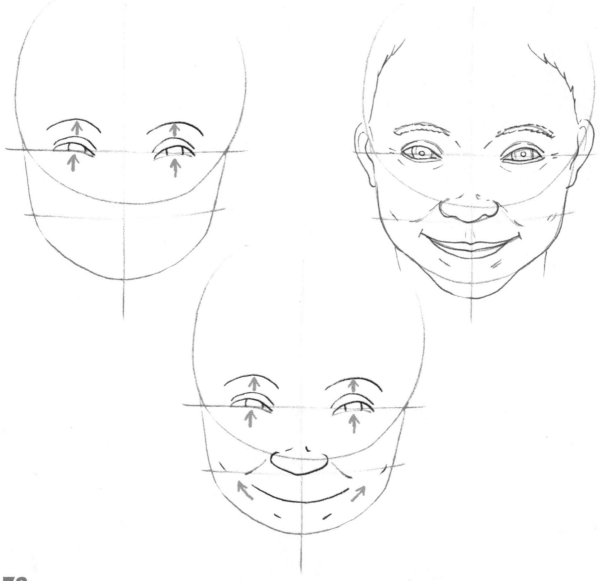

FINISH YOUR DRAWING WITH A PEN

A few fine pen strokes are enough to finish the drawing, so you don't weigh down the youthfulness of a smiling face.

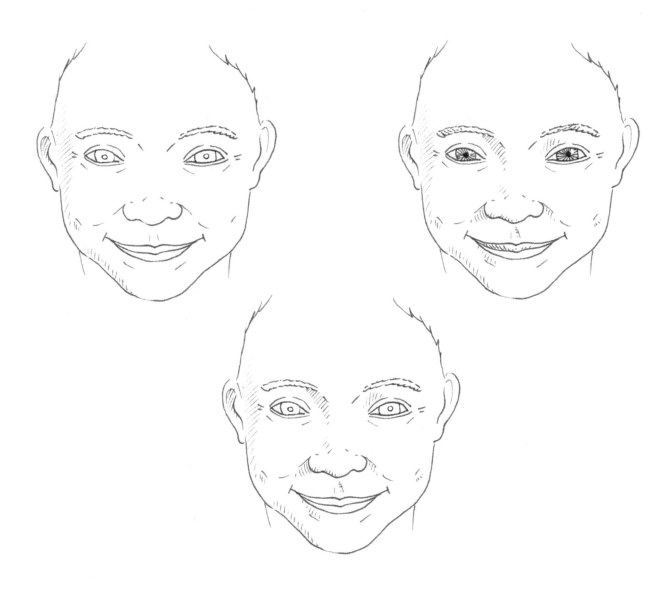

PRACTICE PAGES

Try your hand at finishing the original sketch.

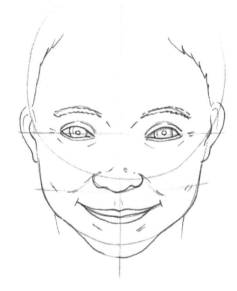

Draw your own version of a smiling face in the space below.

JOY

A very happy face is similar to a smiling face, but with more expressiveness.

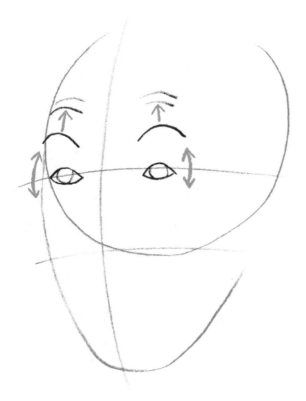

The eyes will be more open, and the eyebrows will be even more raised.

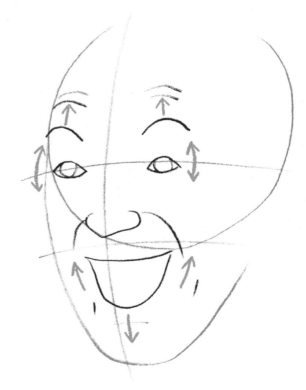

The mouth opens and stretches even more, pushing the chin down.

FINISH YOUR DRAWING WITH A THICK FELT-TIP MARKER

Finish your drawing with a thick felt-tip marker to give the face a dynamic expression.

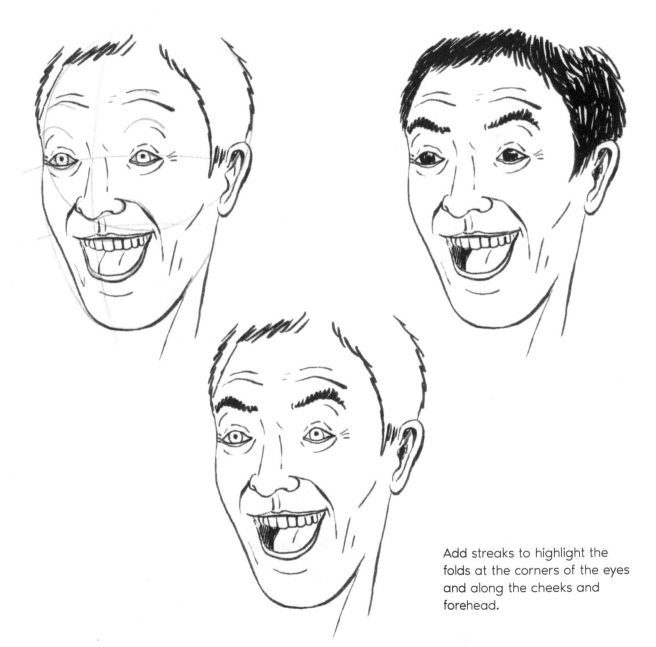

Add streaks to highlight the folds at the corners of the eyes and along the cheeks and forehead.

PRACTICE PAGES

Try your hand at finishing the original sketch.

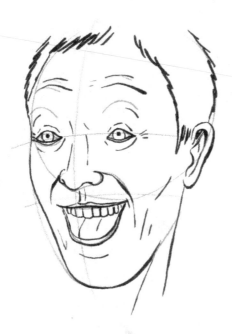

Draw your own version of a joyous face in the space below.

SADNESS

The features of a sad face droop downward.

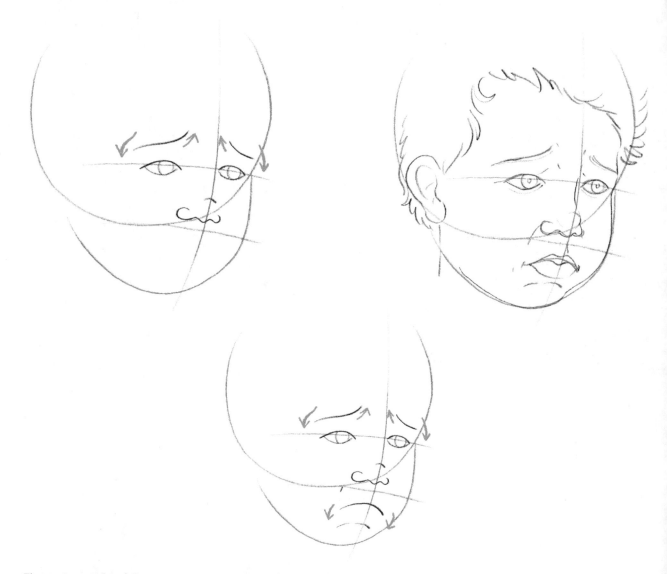

The outer ends of the eyebrows go down and the inner eyebrows go up, making the center of the forehead wrinkle and lift.

The corners of the lips turn down, dragging down the lower face.

Even if the face is very young, you can add a few carefully placed folds to emphasize an expression of sadness, but don't overdo it.

FINISH YOUR DRAWING
WITH A PENCIL

You can achieve a velvety softness in your drawing by gently rubbing the sides of a pencil on the paper.

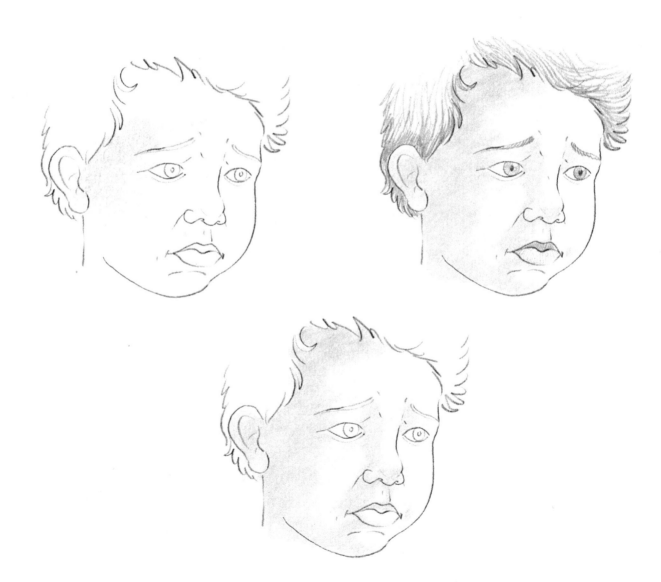

PRACTICE PAGES

Try your hand at finishing the original sketch.

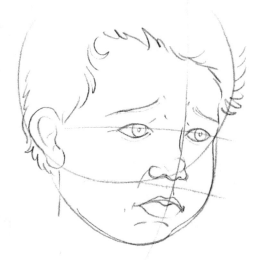

Draw your own version of a sad face in the space below.

ANGER

To convey anger, make the face frown and bunch the features toward the center.

The center of the forehead wrinkles downward, making the eyebrows slightly more arched. The eyes narrow.

As you tense, your mouth tightens and your nostrils rise.

Many angular folds can be added to emphasize an angry expression.

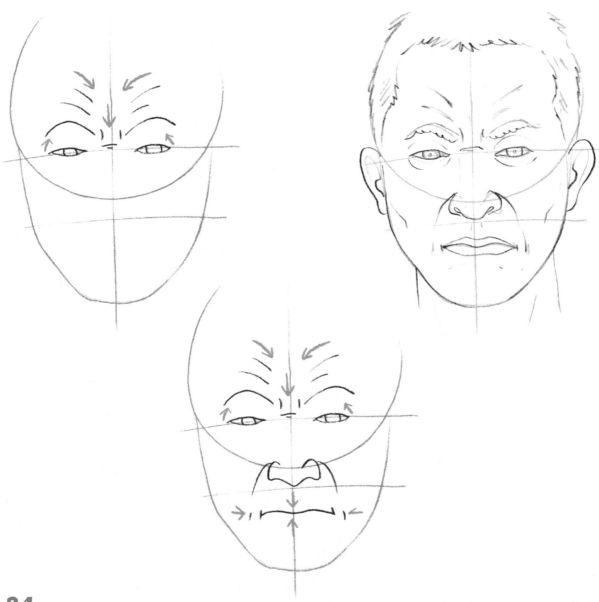

FINISH YOUR DRAWING WITH MULTIPLE GRAPHITE PENCILS

Using multiple graphite pencils will give your drawing intensity without losing any detail.

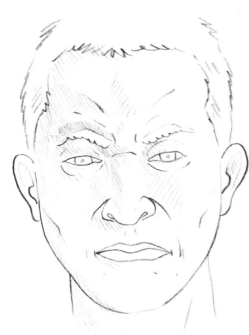

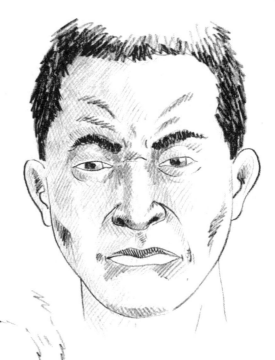

To add energy, cross the lines when layering the hatching of the shadowed areas...

...and quickly darken certain details.

PRACTICE PAGES

Try your hand at finishing the original sketch.

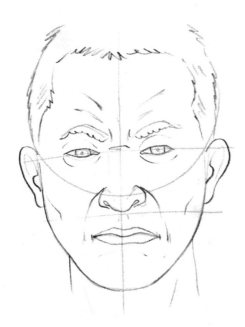

Draw your own version of an angry face in the space below.

A surprised expression will stretch the face and round out the facial features.

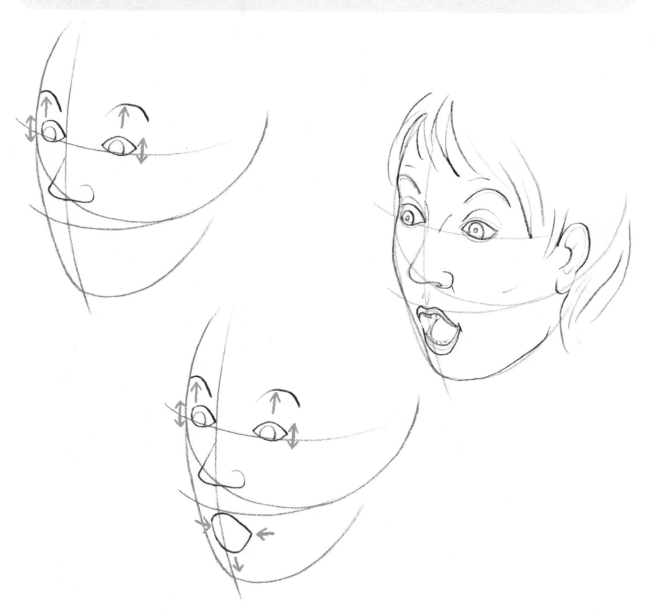

When a face expresses surprise, the eyes widen and the eyebrows rise sharply.

Opening the mouth roundly lowers the chin.

You can add lines around the eyelids and put in folds above the eyebrows.

FINISH YOUR DRAWING WITH A BALLPOINT PEN

Use a ballpoint pen to darken fine hatching.

Use small, thin lines to create a sense of energy.

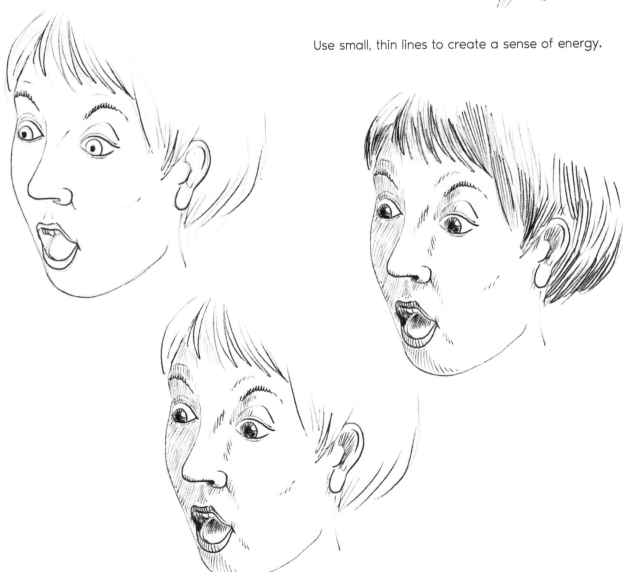

PRACTICE PAGES

Try your hand at finishing the original sketch.

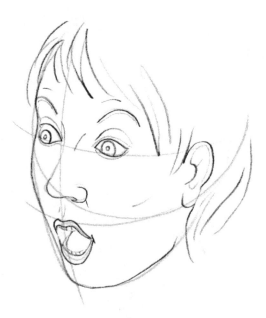

Draw your own version of a surprised face in the space below.

DOUBT

An expression of doubt will twist the face in opposite directions.

The gaze of the eyes tends to be directed upward. The outer eyebrows go up while the inner eyebrows go down.

Twist the mouth to one side, dragging one side of the nose and chin with it.

You can exaggerate the twist of the face and clearly mark the folds that the twist generates.

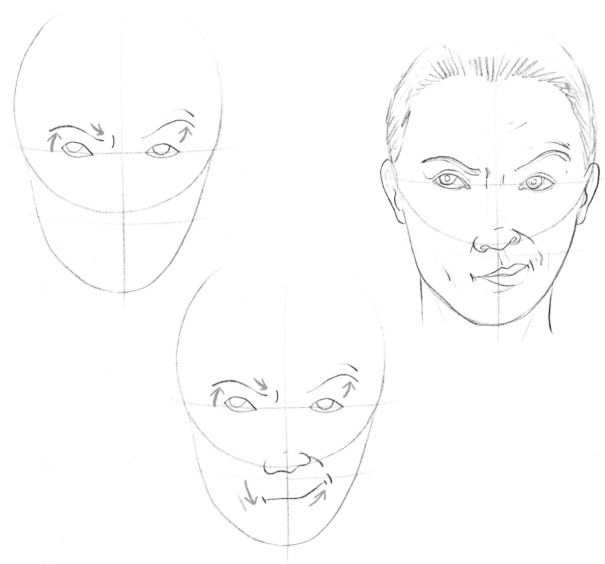

FINISH YOUR DRAWING WITH MULTIPLE BALLPOINT PENS

It's interesting to finish a drawing with two ballpoint pens with different thicknesses.

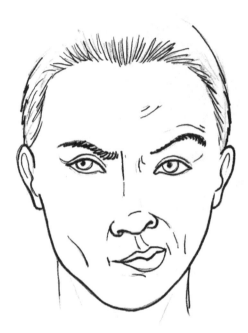

Use the thicker ballpoint pen for the contours and specific details...

...and the thinner ballpoint pen for the shadows and creases.

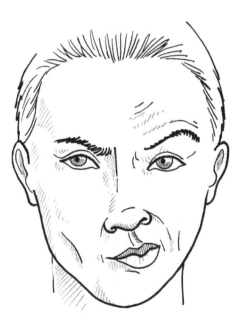

PRACTICE PAGES

Try your hand at finishing the original sketch.

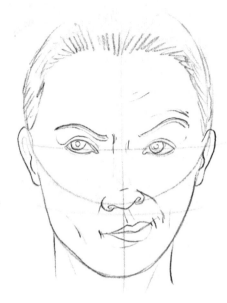

Draw your own version of a doubtful face in the space below.

FEAR

Tilting the head and exaggerating facial features will help to convey fear.

The face tilts backward, cringing. The eyes open wide, looking down. The eyebrows rise and crease the forehead.

The mouth opens wide, stretching the lower face. The nose turns up and the nostrils dilate.

Don't hesitate to wrinkle the forehead and round the holes of the nostrils. The eyes appear to roll into the corner of the eye sockets.

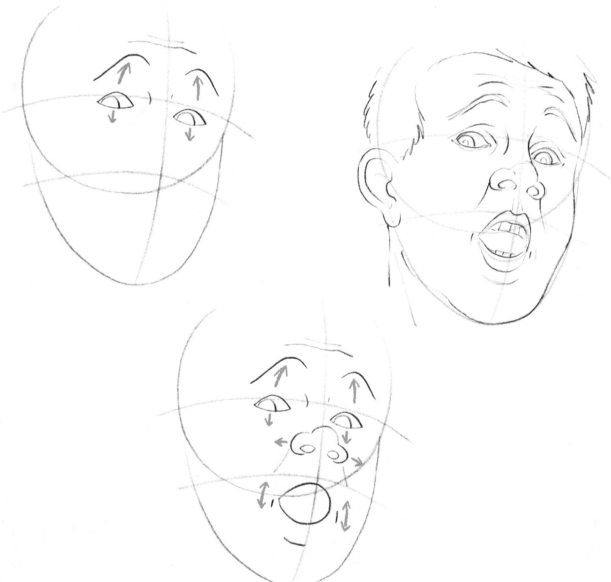

FINISH YOUR DRAWING WITH A GREASE PENCIL

You can finish your drawing with a grease pencil to get intense blacks and dramatic contrasts that accentuate the emotion of fear.

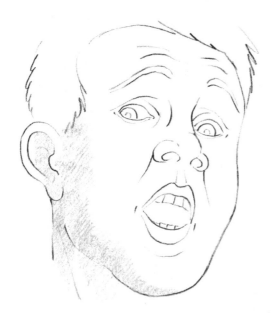

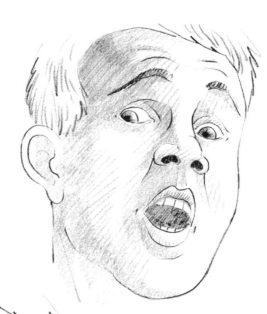

Create strong shadows for variety and to enhance the emotion.

Blacken the hole of the nostrils and mouth.

PRACTICE PAGES

Try your hand at finishing the original sketch.

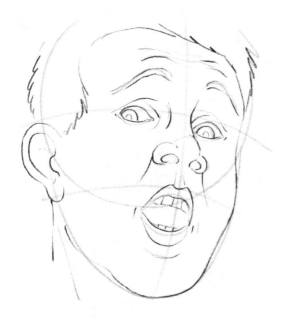

Draw your own version of a fearful face in the space below.

DISGUST

An expression of disgust is mostly concentrated around the mouth and nose. Disgust is often related to taste or smell.

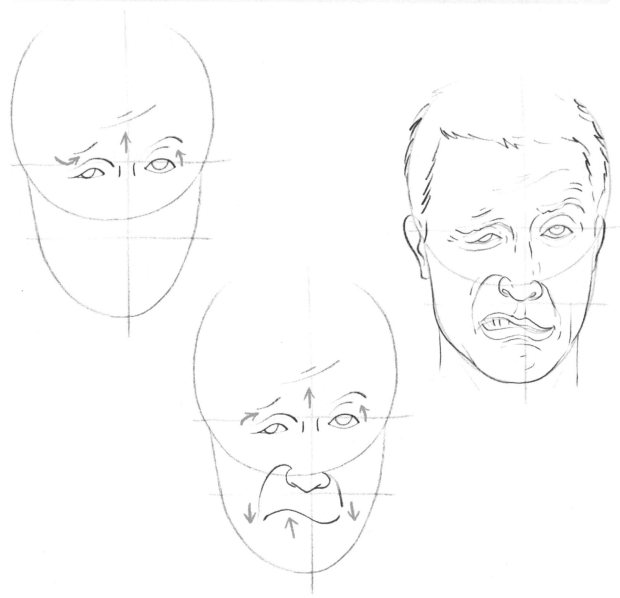

With disgust, the eyes squint and may twist in different directions.

The mouth tightens and twists back and down. The nostrils close and the nose wrinkles.

You can open a corner of the mouth for emphasis, and don't hesitate to wrinkle the face.

FINISH YOUR DRAWING
WITH A FELT-TIP MARKER

A felt-tip marker will add substance to hatching.

Exert more pressure on a felt-tip marker to darken the lines and emphasize the details of the hair and facial features.

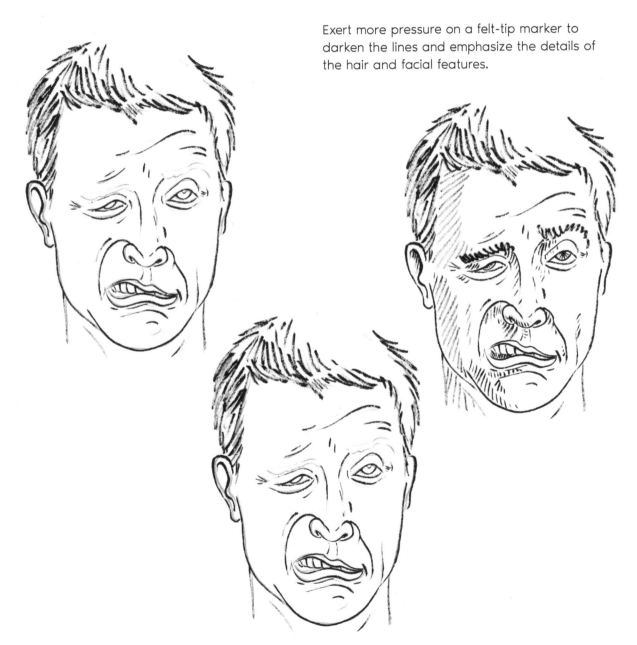

PRACTICE PAGES

Try your hand at finishing the original sketch.

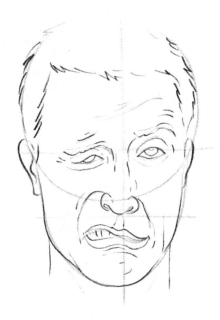

Draw your own version of a disgusted face in the space below.

ABOUT THE AUTHOR

Lise Herzog was born in 1973 in Alsace. From an early age, she used a ballpoint pen to fill sheets of A4 paper with drawings. In search of precision, she persistently studies and reworks her drawings, certain that she figured out how to represent her subjects one day, and disappointed the next. So she starts over. This is how, quite naturally, Herzog came to learn at the University of Plastic Arts and then at Decorative Arts in Strasbourg. In 1999, with her diploma in her pocket, she presented her sketchbooks to publishing houses—and so began her illustrative journey. The same year, she was selected to attend the Bologna Book Fair. Since then, she has illustrated many books for young people and adults, both fiction and nonfiction. Lise Herzog is also the author of several drawing books, including *Drawing Animals* (Ulysses Press, 2020); *Drawing People* (Ulysses Press, 2021); as well as *The Easy Drawing*, *The Successful Drawing*, *Easy Color*, and *Easy Perspective and Composition* from the French publishing house Editions Mango.

Website

http://liseherzog.ultra-book.com

Blogs

http://liseherzog.blogspot.fr

http://machambredebonne.blogspot.fr

Printed in the USA
CPSIA information can be obtained
at www.ICGtesting.com
CBHW080518170524
8648CB00005B/40